JON VAN ZYLE'S
Alaska Sketchbook

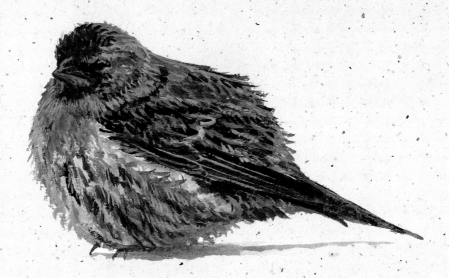

Four Seasons in the Far North

FOREWORD BY DEBBIE S. MILLER

EPICENTER PRESS
FAIRBANKS · SEATTLE

For Char

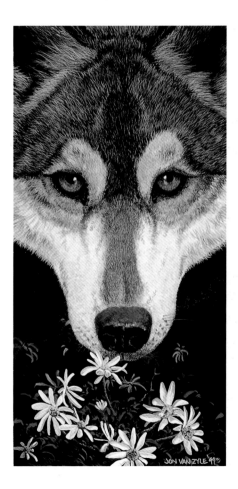

Epicenter Press, Inc., is a regional press founded in Alaska whose interests include but are not limited to the arts, history, environment, and diverse cultures and lifestyles of the North Pacific and high latitudes. We seek both the traditional and innovative in publishing quality nonfiction tradebooks, contemporary art and photography giftbooks, and destination travel guides emphasizing Alaska, Washington, Oregon, and California.

Project Editor: Christine Ummel Production: Todd Communications, Anchorage, Alaska
Cover and Book Design: Elizabeth Watson

"Swoosh," page 10, and "Off on His Own," page 47, were published in the children's book *Honey Paw and Lightfoot,* by Jonathan London, Chronicle Books, San Francisco. "Beneath the Ice," page 11, was published in the children's book *A Caribou Journey,* by Debbie S. Miller, Little Brown, Boston. "Joyful Song," page 17, was published in the children's book *Disappearing Lake,* by Debbie S. Miller, Walker & Co., New York.

Library of Congress Cataloging-in-Publication Data

Van Zyle, Jon
 Jon van Zyle's Alaska sketchbook : four seasons in the Far North.
 p. cm.
 ISBN 0-945397-65-8
 1. Van Zyle, Jon — Notebooks, sketchbooks, etc. 2. Wildlife art — Alaska.
 3. Alaska — In art. I. Title.
 N6537.V328A4 1998
 759.13 — dc21
 98-8684
 CIP

To order single copies of JON VAN ZYLE'S ALASKA SKETCHBOOK, mail $16.95 each (Washington residents add $1.46 state sales tax) plus $5 for priority mail shipping to: Epicenter Press, Box 82368, Kenmore, WA 98028.

Booksellers: This book is available from major wholesalers.

Printed by Samhwa Printing Co., Ltd. Seoul, Korea.

First Printing, September 1998 10 9 8 7 6 5 4 3 2

CONTENTS

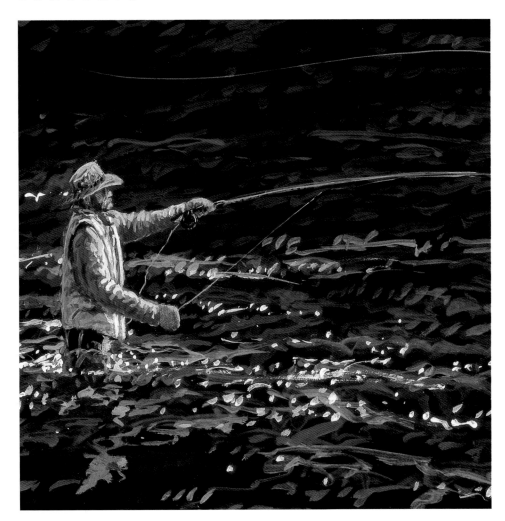

FOREWORD 4

Spring 9

Summer 23

Fall 36

Winter 50

During a recent gallery show, a young girl shyly approached Jon Van Zyle, a modest art portfolio tucked beneath her arm. An admirer of Van Zyle's paintings, the aspiring artist hoped he might critique her work and offer a few tips. Her wish came true.

Talking art with students comes easy for Van Zyle. Art is his love, something he has lived nearly his whole life. Encouraging the young artist, he suggested that she draw at least three pictures every day. He showed her the simple technique of adding a dab of white paint to make a creature's eyes look alive. The appreciative girl listened, watched, and went home inspired.

While growing up in New York and Colorado, Jon and his twin brother, Daniel, were inspired by their mother, Ruth Van Zyle, a gifted, self-taught artist. When the boys were young, Ruth often rolled out sheets of white paper from their grandfather's butcher shop. Jon remembers creating one colorful mural that depicted a pheasant being flushed out of the brush by an Irish setter. The brothers frequently drew pictures of dogs

because Ruth raised and trained working collies. She also hunted pheasants, rabbits, and deer, so they had many opportunities to study and sketch wild animals. Jon grew fond of painting many of the same subjects that still interest him today. Ruth never criticized the brothers' artwork. She simply told them to "do it again" until they had captured their subjects. That practice paid off as the Van Zyle brothers both eventually became renowned wildlife artists.

For many years Ruth Van Zyle had also dreamed of moving to Alaska. Although she never made the move, Jon did fufill the dream, being influenced by his mother's longing to live in the Far North. He gradually moved farther west, acquired a dog team, and arrived in Anchorage in 1971.

In the past twenty-five years, Jon has created hundreds of acrylic paintings and stone lithographs that express the beauty of Alaska's wilderness and wildlife, and his love of nature. Charlotte Van Zyle, Jon's wife of nearly twenty years, has played a significant role in nurturing Jon's artistic endeavors,

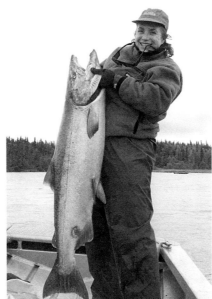

Char with her first fifty-pound Kenai River king salmon.

HAWK "anticipation"

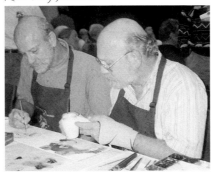

Jon and his twin brother, Dan, participate in a quickdraw for charity in Seattle.

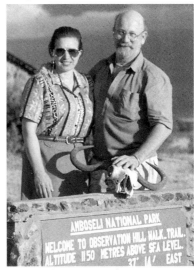

Char and Jon visiting Kenya in 1994.

5

Jon autographing posters in Mississippi.

At a show in Switzerland, Jon meets with his European agents, Heidi Mueller and Kurt Eberle.

Swanap, lots of trees
Young bull yearling
awakened — Spring
hackles up...
dark/moody "wet"

from brisket
on down from memory.
too much tundra moss.

acting as business manager, agent, and publisher. Thanks to this strong partnership based in their home in Eagle River, Jon's artwork has been successfully marketed throughout Alaska, the United States, and Europe.

Each image that Jon creates is a personal reflection of an experience outdoors: witnessing a grizzly emerge from her winter den; racing in the Iditarod; fishing with Char at Salmon Creek; sharing a lake with Canada geese; watching caribou migrate across the tundra; traveling over the ice by dog sled; or gazing into the night sky as northern lights dance.

Through the seasons, Jon paints what he sees, loves, and knows in nature. His studio is filled with paints, brushes, sketch journals, books, photographs, artifacts, bird nests, antlers, rocks, and bones. Alaska's natural world, right out the back door of his home in Eagle River, continually fuels his heart and soul. What Jon takes from nature, he gives back through his realistic expression of America's last great wilderness.

Jon's respect for and representation of Alaska, as seen through this sketchbook,

teach us to look more closely at nature. The images reveal how Jon appreciates the little subtleties: the feather of an immature bald eagle; the claw marks of a grizzly track; the pussywillow color of a chickadee; and the whistle and pop of the northern lights. Each episode shows the deep connection between the land, the man, and his art.

In recent years I've had the pleasure of working with Jon on several children's nature books. Children are captivated by his pictures. His full-color illustrations bring simple words to life, creating scenes that vividly show nature's dramas. I've been struck by Jon's conscientiousness as he carefully portrays the wildlife and habitats described in the stories, paying great attention to detail.

Through his illustrated books, original paintings, and prints, Jon is building a legacy that genuinely reflects Alaska, its beauty, and its many natural treasures. Such a legacy is a great and lasting gift.

— Debbie S. Miller
Fairbanks, Alaska

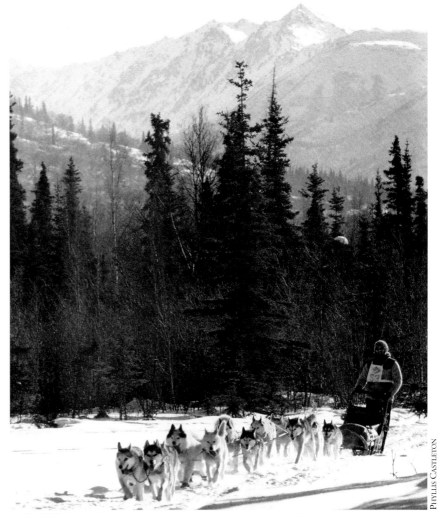

Jon's 1979 Iditarod dog team leaves Anchorage on its way to Nome.

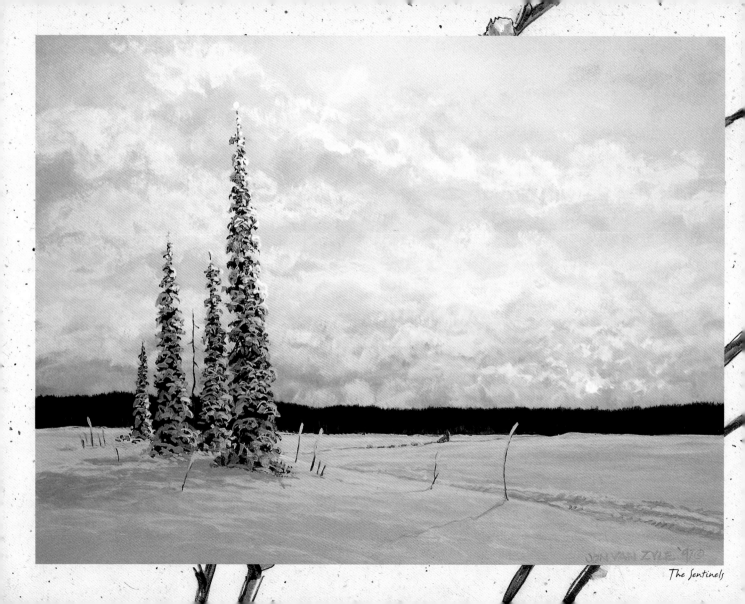

JON VAN ZYLE '91 ©

The Sentinels

Spring

In Alaska, we call it "breakup." Depending on where in Alaska you live, spring lasts from two weeks to two months, usually beginning in late March or early April.

It's a time of reawakening. The ground is transformed from four-feet-deep frozen gray-brown dirt into thawing mud. As the snow melts you find things that you lost during the winter: axes, a single glove, maybe even your mind. In turn you are found by mosquitoes — the big guys who have wintered over and are beginning to crawl up through the snow, along with the purple crocuses.

Despite the bugs, it's a great time to explore; the undergrowth hasn't exploded yet to block your path. Don't blink, though, because in a few days it will be GREEN! With all the daylight hours, the woods come alive with every shade from chartreuse to emerald.

Mid-March - May
temps — day, 20s to 30s
 — night, minus 5 to 30s
snow — 9-14 inches, some rain late May
avg. hours of daylight — 11½ to 17½

9

MARCH 20, 18° F
SUNNY, SNOW LAST NIGHT

At home in Eagle River Valley

Mom grizzly came out of her den today. She's spent the past few days inside, near the entrance, but today she came all the way out. For about an hour we waited for her cub to follow. We caught fleeting views of his ears or rump before he finally made his appearance, tentative at first, then more brave in his explorations.

Mom stretched and rubbed, getting out the kinks after her long nap. Several times she folded her legs and slid down the hill, the cub following. About three o'clock they crawled back into the den—probably to snooze away the day.

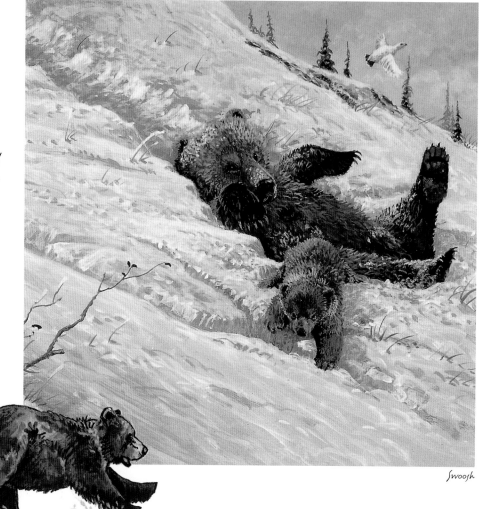

Swoosh

MARCH 29, 28°
SUNNY, HIGH CLOUDS
COLD LAST NIGHT, -5°
13 HOURS OF DAYLIGHT

Today the caribou crossed the lake. The small herd of about thirty animals milled about, pawing at the snow, exposing old muskrat push-ups. Each "push-up" contains a cache of grass, stored there by those clever rodents. The caribou must be hungry due to the deep snow; turning to this food source means they're desperate. After an hour they drifted off toward the mountains — just a short stop at the diner on their long journey.

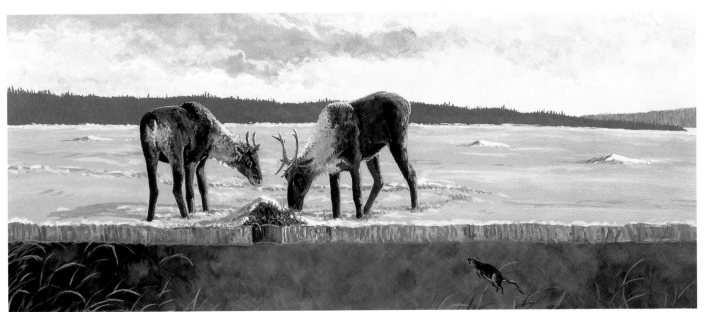

APRIL 7, 32° AND WINDY. 18° LAST NIGHT.

Morning Light

Spring comes hard to this part of the world. Winter's grasp is long and firm, and she doesn't give it up easily. Today I took my dog team upriver to see two old friends. They were married on this riverbank in April of 1943, in their own church, as they like to say. The ladies from the three villages upriver made her a beautiful moose-skin wedding dress; he wore his "Alaska tuxedo," braided his hair, and put on new moccasins. They've spent the last fifty-plus spring seasons here watching the river — and their lives — go by, gathering knowledge as only those who live it can.

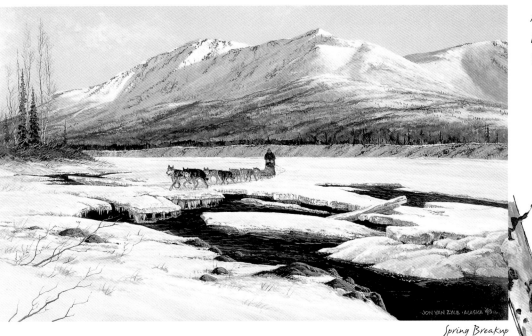

Spring Breakup

Today I traveled downriver to visit Michelle and
Alan, and to bring them some cranberry bread.
In a couple of places I gave Pikaki her head and
trusted her senses and savvy to get us across the ice.
I enjoy watching her instinctively "feel" her way over
the worst stretches. We did break through once, but
only for a moment, as she reversed direction
and hauled the team out onto hard ice. Lead dogs
like her are few and far between.

colors of birch

purples-
browns
& pinks

(hilites pure white)

13

MAY 1
SUNNY, 52°, 17 HOURS OF DAYLIGHT

Spring sun. The rays are warmer now, although there's still snow on
the ground. Some bare patches on the south slopes. Willows facing
the sun have sprouted young pussywillows. They seem to glow with
color: subtle pinks and purples, grays too. To me, the simplicity of the
branches seems Japanese in style. I love the highlights on the
brambles and buds. . . .

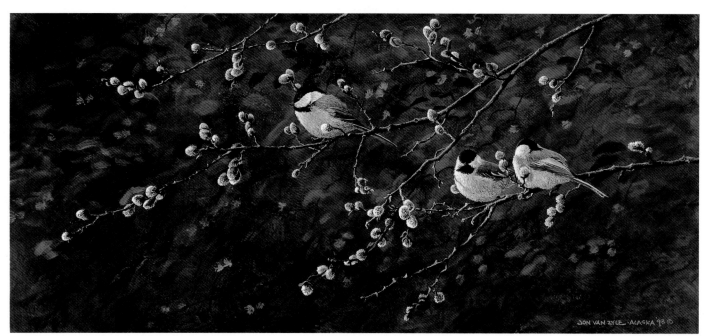

spring's Passage

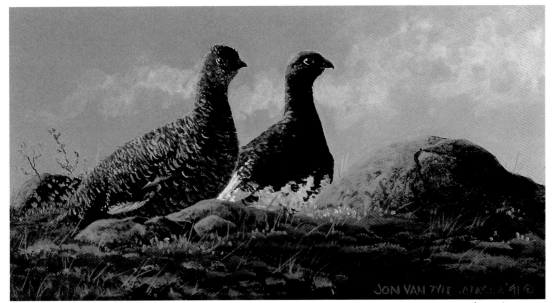

Spring Ptarmigan

. . . Chickadees and redpolls fly in and out of the dog lot, snatching bits of shredded winter coat to line their nests. The chickadees remind me of the pussywillows — up close their coloration is much the same. The ptarmigan are losing their white feathers and becoming more active. Soon their chicks will be scampering among the leaves and sedges.

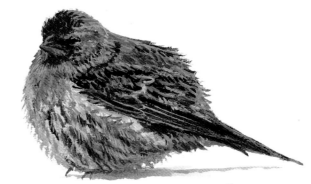

RESTING REDPOLL ♂
ALL FLUFFED UP IN THE SUN.

MAY 19, 58°
PARTLY CLOUDY

*V*isited our lake today. It's a vernal lake, coming and going each year. Earlier this season, as the snow was melting, the little valley slowly filled up with water. Now it's spring, and the grasses and early flowers are coming up. I love to watch all the wildlife that makes the lake its home for a brief time. The white-crowned sparrows are especially thick this year, as are the voles.

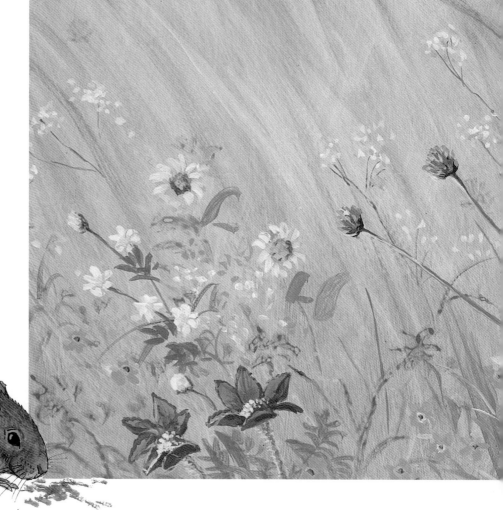

Nort. red backed vole

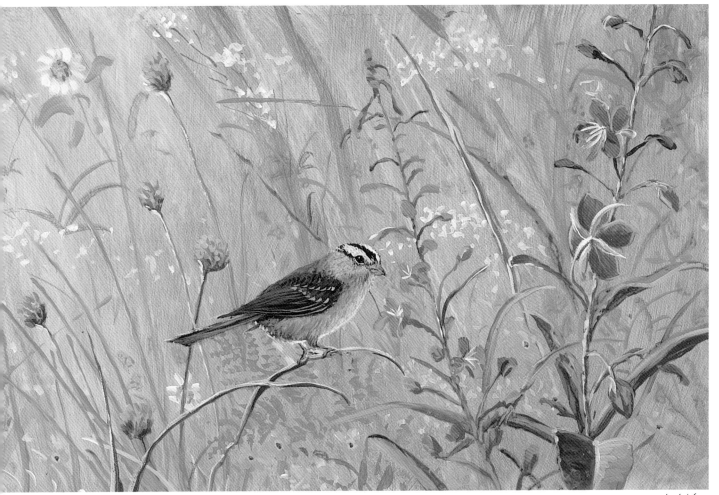

Joyful Song

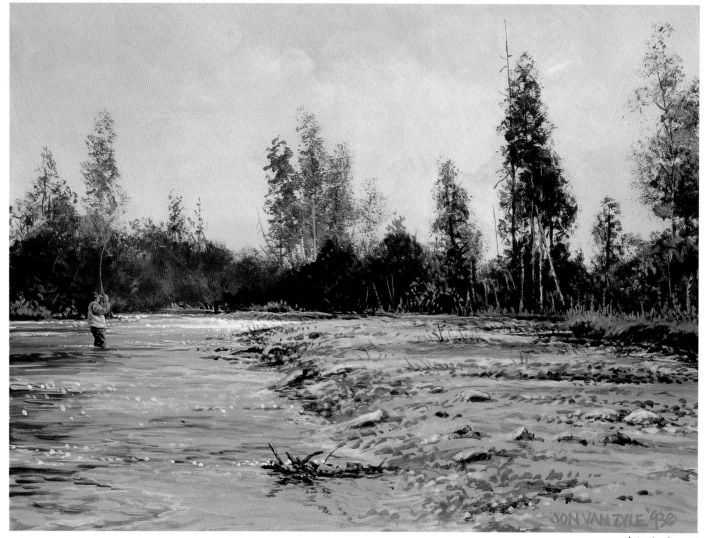

Into the Current

The king salmon have arrived. We hurried downriver to Salmon Creek with our fly rods. Standing on the gravel bar we watched several of these torpedoes with fins navigate their way around a spruce snag. About a half-mile up is a great pool we call the "Fall In" — for obvious reasons. Char's first cast hooked a forty-pounder. She had a heck of a time once that fish left the pool and headed into the fast current. Up and down she ran after the fish, whooping and yelling. By then I had one too and couldn't help her. A medium-size king on an eight-weight fly rod is fun!

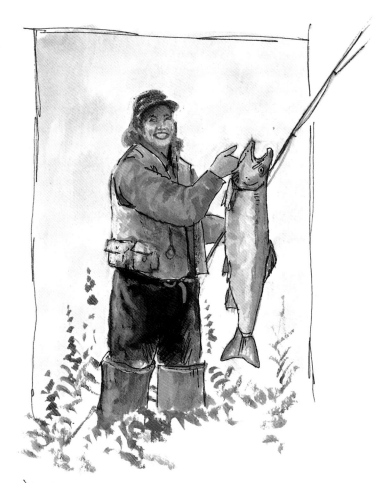

> hilites —lots of them

MAY 30
COOL LAST NIGHT, 38°
WARM TODAY, 58°

Valdez

The sun burned off the fog
bank around nine this morning.
The water was almost flat
calm; the cliffs and the sound
were alive with birds. Common
murres, kittiwakes, millions of
gulls . . . I think I saw a Sabine's
gull, rare in these parts. Of
course the puffins were flying
in and out of their nests high
on the grassy cliffs, their bills
stuffed full of fish for the kids.
The whole menagerie made for
anything but a hushed sound.

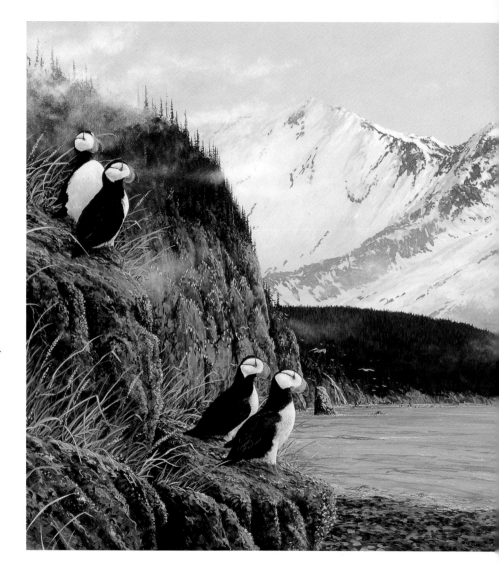

Hushed Sound

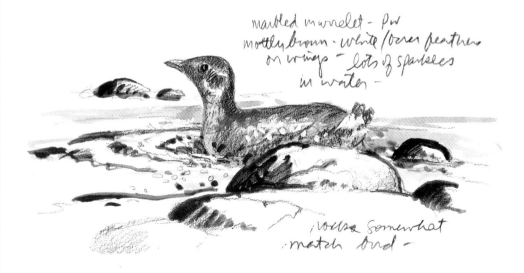

marbled murrelet - pw
mottly brown - white/brown feathers
on wings - lots of sparsees
in water -

rocks somewhat
match bird -

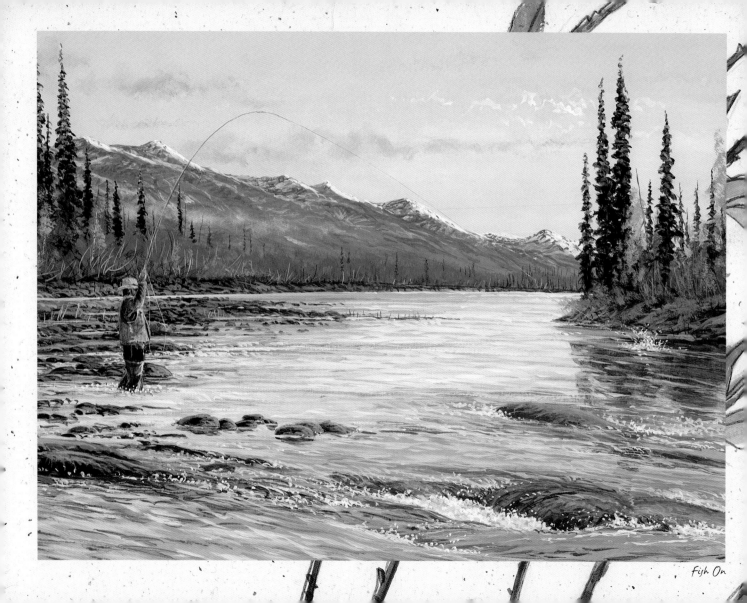

Fish On

Summer

Short as it is, Alaskans love summer. And why not — we spend six or seven months of the year waiting for it. Long, bright days make this a time of fishing, gardening, doing home repairs, and enjoying visitors from Outside. The cool green woods come alive with every kind of bird and critter. Bouquets of color flower in gardens and flourish in the constant daylight.

Summer here is a combination of sunshine and rain. Our flora is fragile, shallow-rooted to keep it from freezing in the winter. So we need rain to keep it from drying out in our normally dry air.

Fishing is our favorite pastime — we can be found on the riverbank, catching reds and silvers, whenever possible.

JUNE - AUGUST
temps — 50° to 80° F
rain — 5" to 6"
avg. hours of daylight — 18½ to 20

23

JUNE 5. 65°
RAINING

Got back from Juneau this afternoon. The art show had gone well, and afterward I went fishing with friends. We paddled up the creek. Saw Mendenhall Glacier through the trees with its icy blues in the gray light. I don't think I've ever seen so many eagles!

 I counted eighty-seven before losing track. One eagle landed right beside me on the gravel bar, strutted up and down for several minutes, then took off. His wings, grabbing the air, made a wonderful sound of silence and power. As he flew away, a wing feather spiraled to the ground.

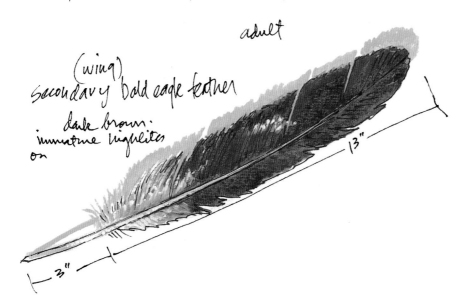

adult

(wing)
secondary bald eagle feather

dark brown.
immature highlites
on

13"

3"

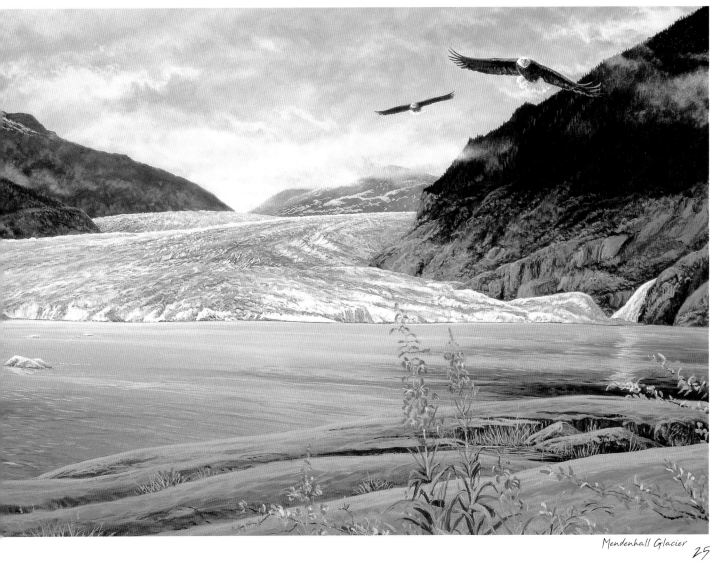

Mendenhall Glacier

25

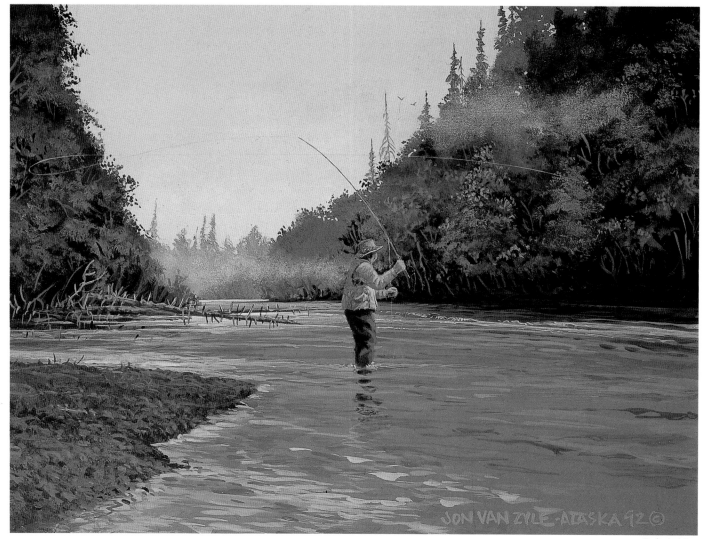

26

Calm Waters

JUNE 15 — COOL LAST NIGHT, 43°
TODAY SUNNY, 61°

Watched a middle-aged man and his ten- or eleven-year-old son
come through the woods to my fishing spot. They had not known
I was there and apologized for their intrusion.

 I was taken by the obvious joy this man took in being with his
son. More than once I saw him put his arm around the boy; a
couple of times he admonished him for some wrong deed. The kid
was a good little fisherman, too . . . in fact, I think he caught more
fish than his old man. We shared views, both natural and political,
for a few minutes over my small lunch fire. When they left, the
young man waved and then went off along the trail behind his dad.

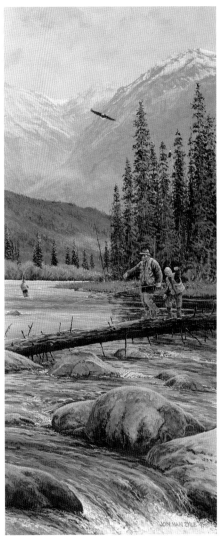

Watching Our Balance

*F*lying to the cabin with Doug, our pilot, we look forward to a week or two of fishing and relaxation. It gives me time away from the easel, to recharge my mind with new images for paintings, or perhaps new ideas for a familiar theme.

We've flown many miles with Doug and Danny, two brothers who know an airplane like I know a paintbrush. Here in Alaska, in order to get to most places, we must fly. It's not uncommon to look into the sky and see three or four small airplanes all going their separate ways. Flying feels as natural to Alaskans as driving does to most other people.

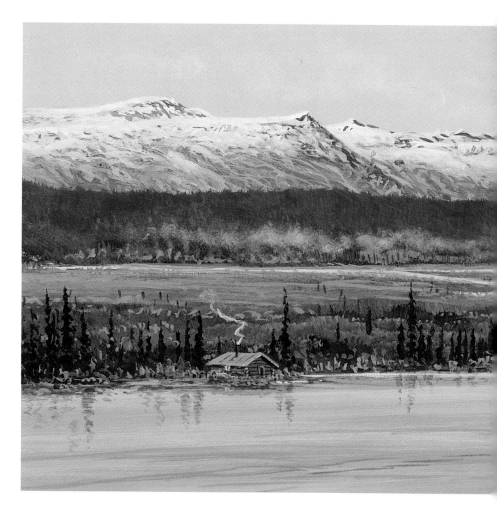

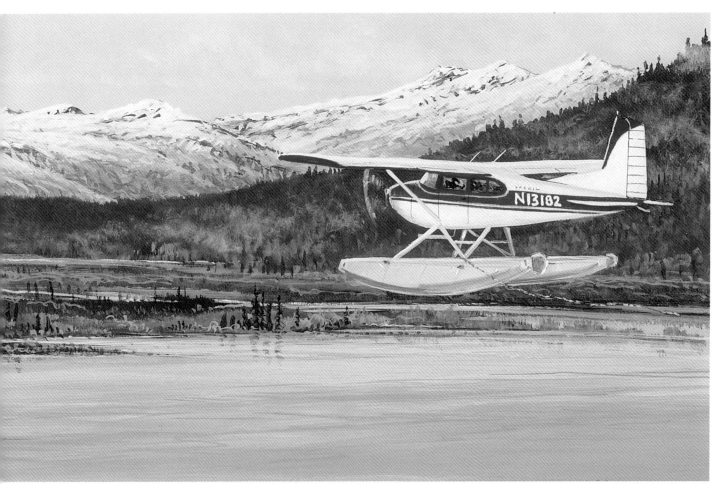

N13182

The Perfect Spot 29

black
black
w/ wht.

The two loons drifted slowly toward me; they couldn't see me sitting on the bank, drawing them. I see their eyes clearly now. Each time they blink it's like slow motion. The iridescence of the greens turning to blues turning to blacks on their heads will be hard to capture in paint. I'll have to glaze it about a million times.

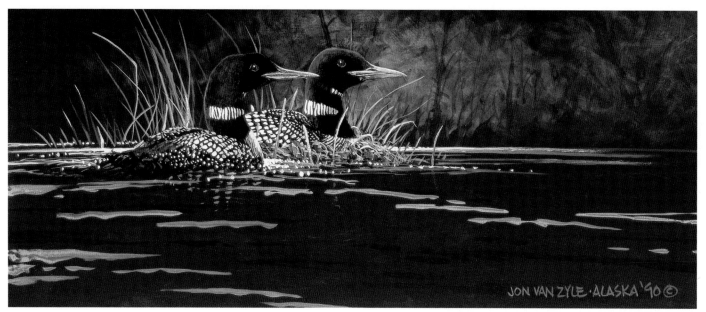

JON VAN ZYLE · ALASKA '90 ©

Loons

JULY 20, 18 ½ HOURS DAYLIGHT
75°, DRY, SUNNY – NEED RAIN

After a breakfast of scones and bacon, we took the canoe across the lake to a cove. Saw grayling flashing their huge dorsal fins in the shallows. Our bald eagles flew over as we headed home. They have a nest in the cottonwoods near the river. It's not very big so it can't be too old, and they're adding to it already. I hope they have young this year.

On our way back the canoe sprang a leak. Some roofing tar and a sliver of wood fixed it, along with our trusty duct tape.

darks of true in spine match bird near nest – cottonwood tree. Snag.

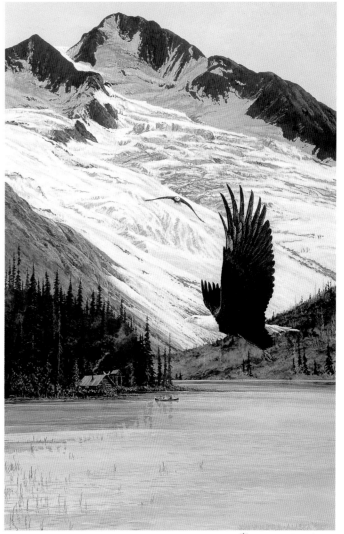

AUGUST 16, RAIN TODAY
HIGH 65° - LOW 52°
16+ DAYLIGHT HOURS

Back at home.

Summer is the best time to
have puppies. They grow up fast
in the warm sun, feeling less
stress than in the cold. Pikaki's
litter is growing by the day. As
a rare treat they were allowed
to come in the house for a few
hours. After a rousing romp and
a bit of chow, it was nap time.

The puppies' personalities are
emerging. One of them is
especially protective of his water
bowl and frets over it constantly.
He refused to go to sleep until
the others left it alone.

Their puppy breath is gone
now that Pikaki's weaned them. I
love that sweet smell — I think it's
what I most associate with puppies.

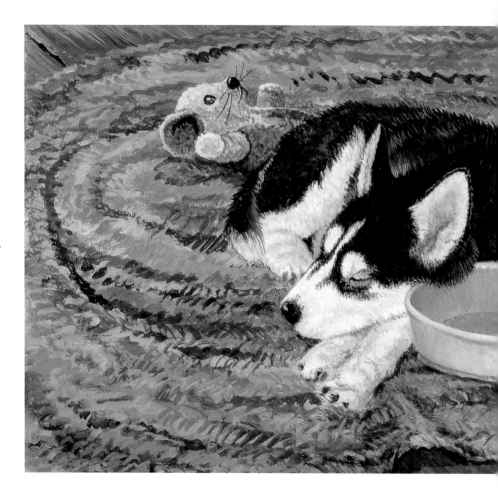

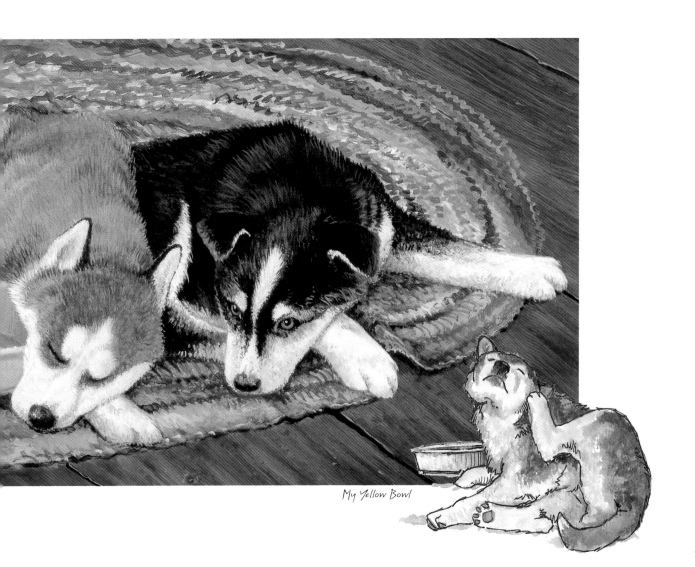

My Yellow Bowl

33

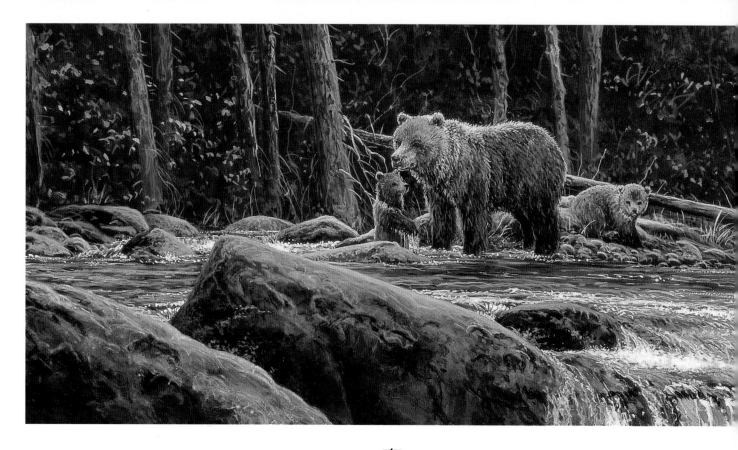

AUGUST 28
65°, SUNNY
15 ½ HOURS DAYLIGHT

The sow cautiously brought her three cubs down to
Salmon Creek. The one little guy was shy and
afraid, holding back behind Mama. The other two
never even thought twice about jumping in. Mama
rarely showed herself, but occasionally she'd

Last One In

encourage the last one in and then return to the
thicket. Eventually the shy one became braver,
and soon he was playing with his two sisters. I'm
sure within a few months — if he makes it — he
will become the aggressor.

Male close by
dark chocolate color ...

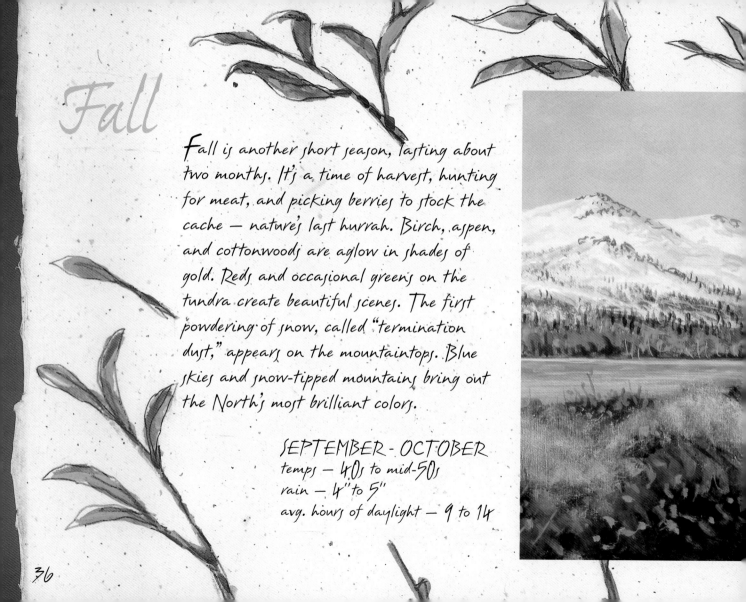

Fall

Fall is another short season, lasting about two months. It's a time of harvest, hunting for meat, and picking berries to stock the cache — nature's last hurrah. Birch, aspen, and cottonwoods are aglow in shades of gold. Reds and occasional greens on the tundra create beautiful scenes. The first powdering of snow, called "termination dust," appears on the mountaintops. Blue skies and snow-tipped mountains bring out the North's most brilliant colors.

SEPTEMBER - OCTOBER
temps — 40s to mid-50s
rain — 4" to 5"
avg. hours of daylight — 9 to 14

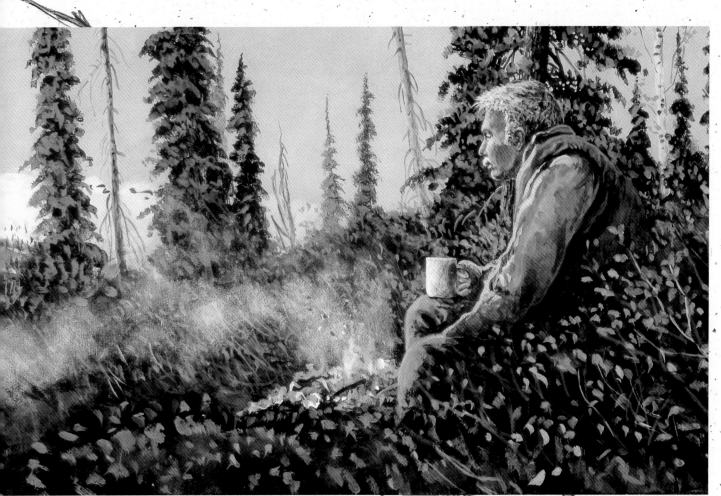

Autumn in the Woods

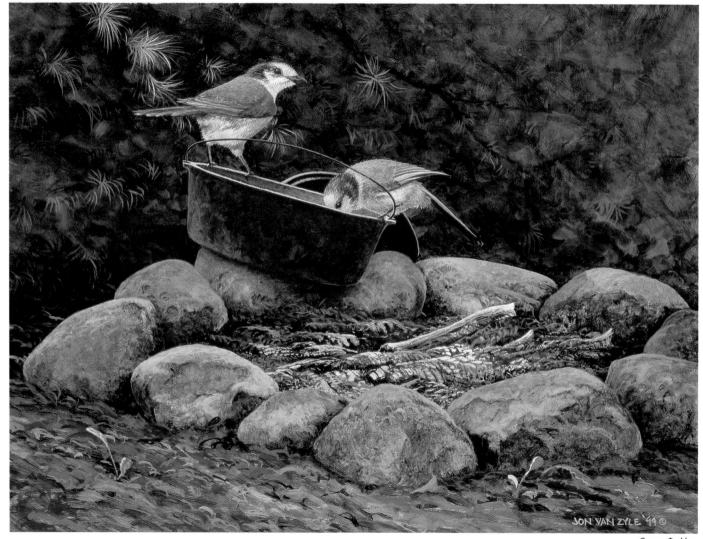

JON VAN ZYLE '99 ©

38

Camp Robbers

SEPTEMBER 3
CRISP 50°
13½ HOURS DAYLIGHT

Somewhere in the corner of my
dream I heard the clatter of
gray jays outside our tent. Their
friendly, inquisitive faces were
waiting for us to serve them
their breakfast. Later, we sat
watching as they boldly ate out
of the Dutch oven — I'm sure
they were discussing the merits
of my biscuits. To anyone who
has ever camped in Alaska, this
is a familiar scene remembered
with fondness.

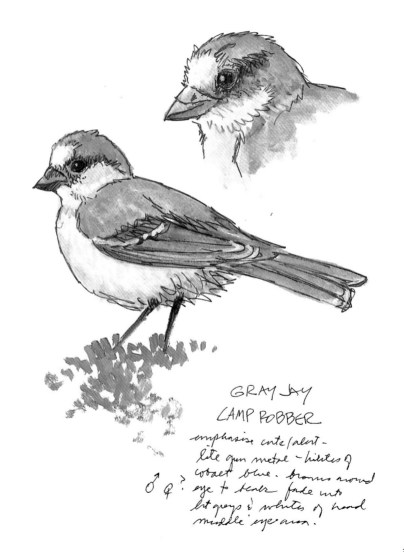

GRAY JAY
CAMP ROBBER

emphasise cute/alert -
lite gun metal - hilites of
cobalt blue. browns around
eye + scalp fade into
lit grays + whites of head
♂ ♀ ? middle eye area.

SEPTEMBER 11, WINDY
SUNNY, BRIGHT – 52°; COOL AT NIGHT – 45°

We sat on boulders in the creek most of the day, watching the family of Canada geese that share their lake with us. They arrived in the spring, hatched their young, and raised them here. Now it was almost time to go. Patiently the parents called the young geese to spend more and more time circling the lake, polishing flying skills for a long journey south.

On this day of their departure, I felt a gentle loss. Never before had I observed the entire lifetime of a wild creature, and now I was losing that kinship. I hope they will stop by for a visit next spring and perhaps raise another family on the lake.

JUNIORS MISSING OUT ON SOMETHING...

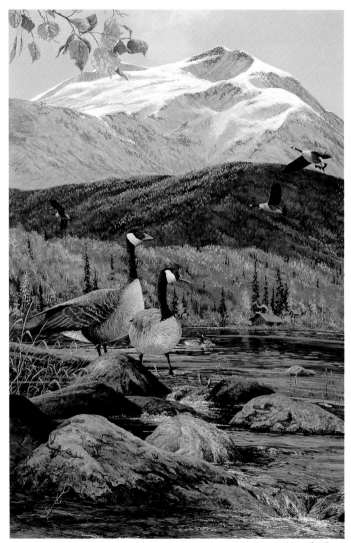

Canada Geese

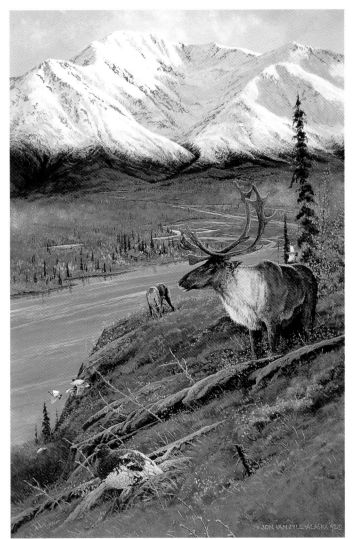

Home on the Range

Caribou are massing. The cows come first in bands of twenty to thirty, their calves with them. I admire these wild animals possibly more than any other. Their twice-yearly journeys of hundreds of miles to their calving grounds and back — facing river crossings, mountains, hordes of mosquitoes, wolves, bears — are tremendously demanding and dangerous.

Today at the river I watched an old cow (probably a scout) pace back and forth, grunting and snorting. She couldn't see me hiding in the willows but she must have smelled me. I watched her "spy hop," releasing the "danger" scent from her hind legs to warn her group and all who followed not to cross at this point.

SEPTEMBER 30
HIGH CLOUDS, 48°

We watched for four hours as more caribou came over the ridge and continued east . . . first one, then two, now three. Occasionally they stopped to snatch a few mouthfuls of tundra moss. Some of their antlers were still encased in brown velvet, but many of the bulls had begun to wear this coating off, and shreds of it hung down. Cows' antlers are smaller. Antlerless calves spent their time trying to catch up to Mama. The clicking of hooves as they walked made it a noisy entourage.

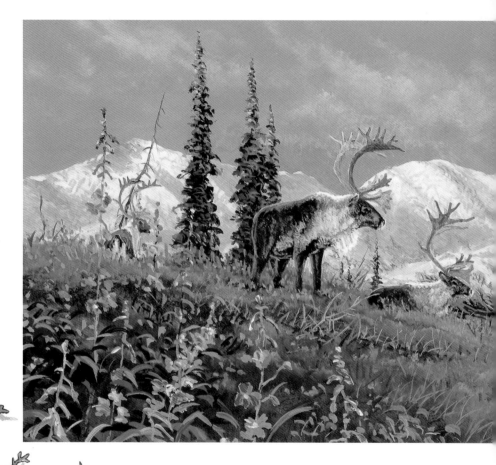

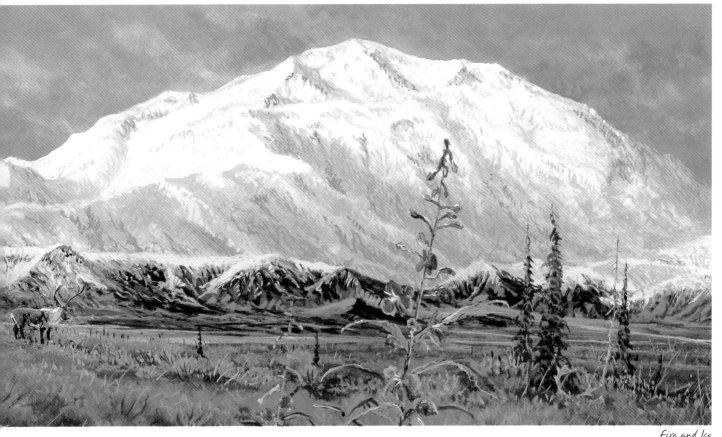

Fire and Ice

The scene was full of the colors of fall: the reds and golds of the
tundra, the caribous' tans and browns, white capes and rumps. . . .
Denali in the background made it all come together.

Out fishing today, there was a definite snap in the air. Last night our mountains received their first "termination dust" . . . it might not stay, but it sure brought the temperature down. I guess it's too early to call it an Indian summer, but it sure feels like magic in the air.

We caught a mess of land-locked silvers and trout, which came readily to my glow bug fly and Char's egg-sucking leech fly. Great fish . . . big, frying pan-size!

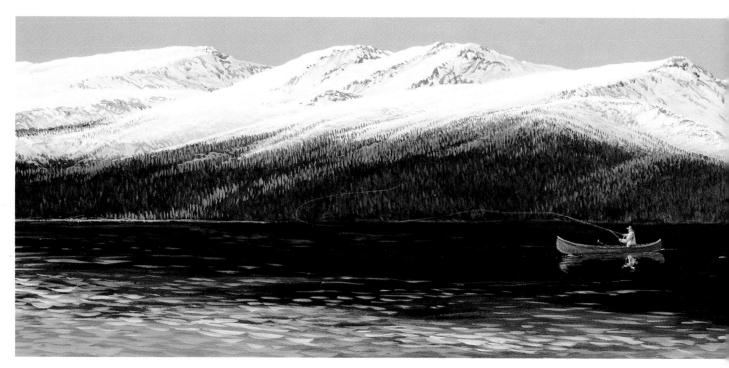

DIANE'S PURPLE FLY

ROYAL WULFF

MOSQUITO

EGG SUCKING LEACH
WOOLEY BUGGER

JONA'S

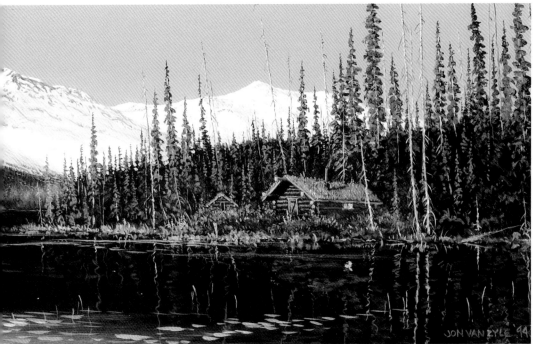

JON VAN ZYLE '94

Magic Times

OCTOBER 11 – 39° DAY
30° LAST NIGHT
CLEAR, COLD, SUNNY

The orange of the trees and bushes contrasts greatly with the brooding gray sky. A bull moose with a fifty- to fifty-five-inch rack courted one of his lovely brides-to-be. I swear their noses and lips must be on a swivel. Last year this same guy eventually had eight cows in his harem, and successfully

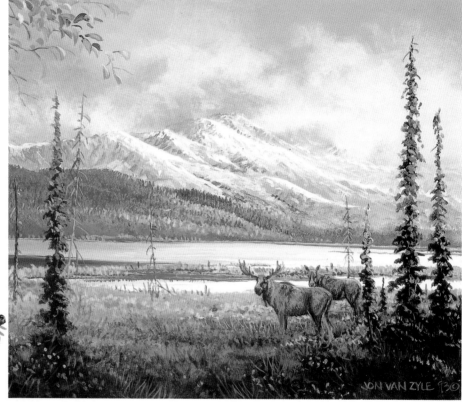

Moose Love

DWARF BIRCH LEAVES
multi color - browns to yellows
reds - mostly orangy red (lite on back)
some brilliant reds. ½ to ¾" serrated
edges.

pulpy-sweet
great w/ blueberries
(after frost)

leaves clustered
on branches.
array of leaves.

defended them against all rivals. His antics are great to watch. I wonder if the tables were reversed and these guys watched us in our courting rituals, would they be as amused?

46

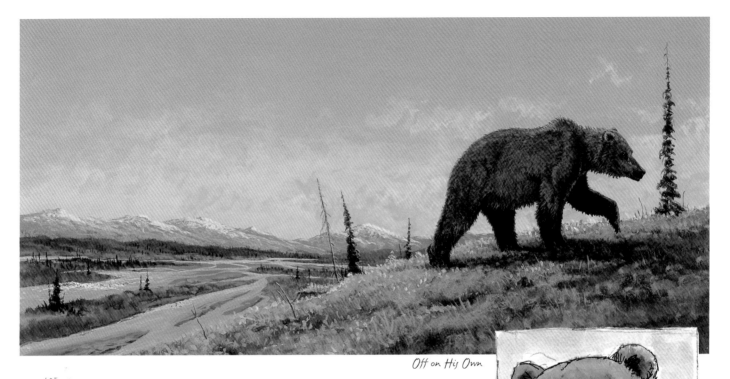

Off on His Own

OCTOBER 13 — 35°, 9½ HOURS DAYLIGHT

A lone grizzly, two and a half to three years old, came
by the cabin today. He hung around just long enough to
eat a five-gallon can of Blazo — so much for my winter
supply of fire starter. These young guys have just been
chased away by Mama and are quite dangerous.
I last saw him climbing the hill across the river. . . .

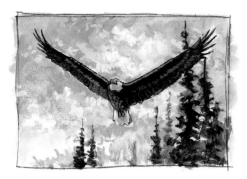

OCTOBER 29
28°, STORMY

We watched as he soared around the cottonwood trees in an ever-widening circle. Winter is in the air — it's already snowed in the high places. Soon it will be the season of hunger. The salmon are all but gone, a few white carcasses left lying in the gravel bars. As the eagle slowly flies off into the mountains, I know our national bird is in for hard times . . . I pray we do not follow.

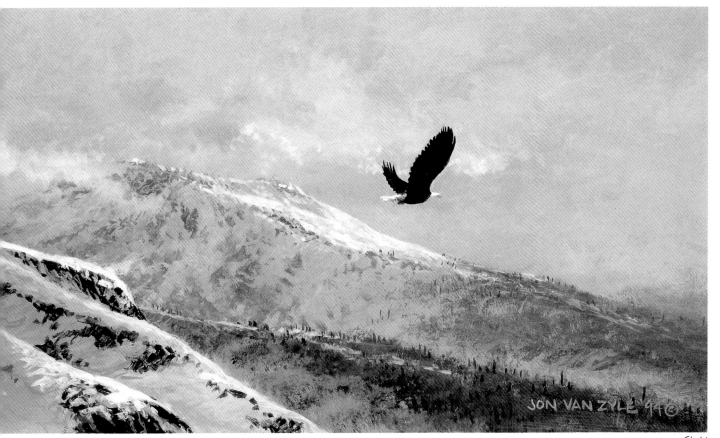

Flight

49

Winter

Without a doubt, my favorite season in this great land is winter. While some would say that this longest of Alaska's seasons is one of sleep, I disagree — I can't sleep for fear of missing the spruce trees heavily laden with snow, standing guard to awaken me in the yellow of dawn. It's hard to sleep when the temperature sinks crisply below zero and the white snow reflects the blue of the sky; when there are dogs to run, skis to wax, wood to split; when rosy-colored sunsets light the mountains' snow on fire with alpenglow; when the awe-inspiring northern lights are crackling and whispering overhead; when your very core shouts, "This is Alaska."

NOVEMBER - FEBRUARY
temps — minus 30° to 25° F
snow — 70" to 80"
avg. hours of daylight — 7 1/2 to 10 1/2

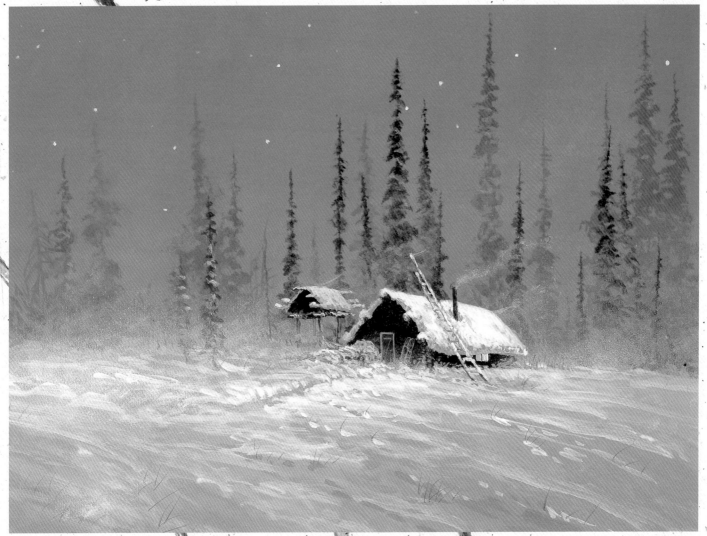

Ground Blizzard

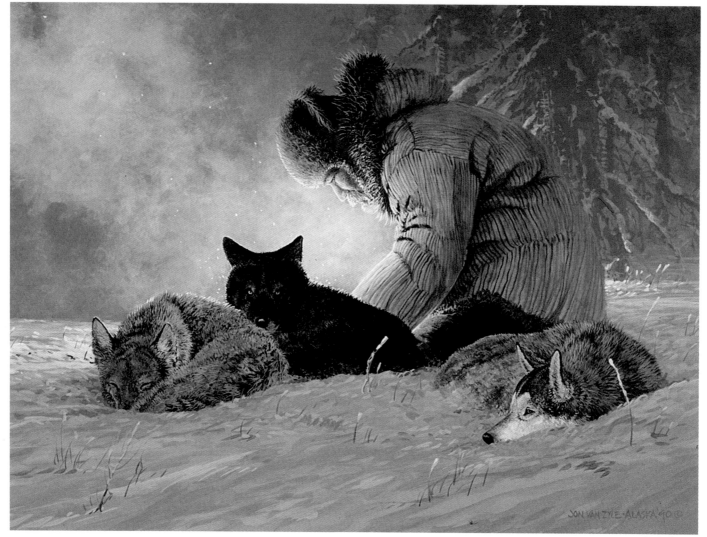

52

Firelit Musher

NOVEMBER 24 — COLD, CRISP, DRY
DROPPED DOWN TO -15° LAST NIGHT

My time on the trail today was without incident. We saw the usual marten and snowshoe hare tracks and the occasional moose. No wolves, though.

The wind was quiet and the sky blue except for mare's tails late in the day; the nice weather will change in a day or two. I stopped around four o'clock, cut spruce boughs for the dogs' beds and mine. The thermometer on the sled showed twelve below. Fed the dogs. Sa and Smokey told me they'd worked hard and would like some smoked salmon for dessert, so I gave them all some — they're such good dogs. Had a nice meal of rice and moose strips myself.

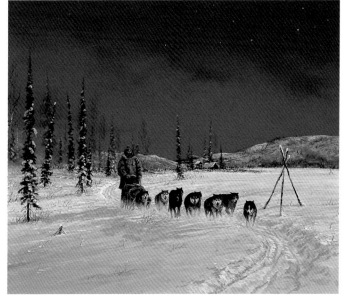

Starry Night

The fire feels good as I write this by its light. At this temperature its warmth can be felt for only two or three feet away; it's now minus ten and I feel half baked. I've spent many nights at peace with myself, alone with my dogs. It's at these times that I remember who and what is important to me, when my thoughts come most clear and memories are made.

53

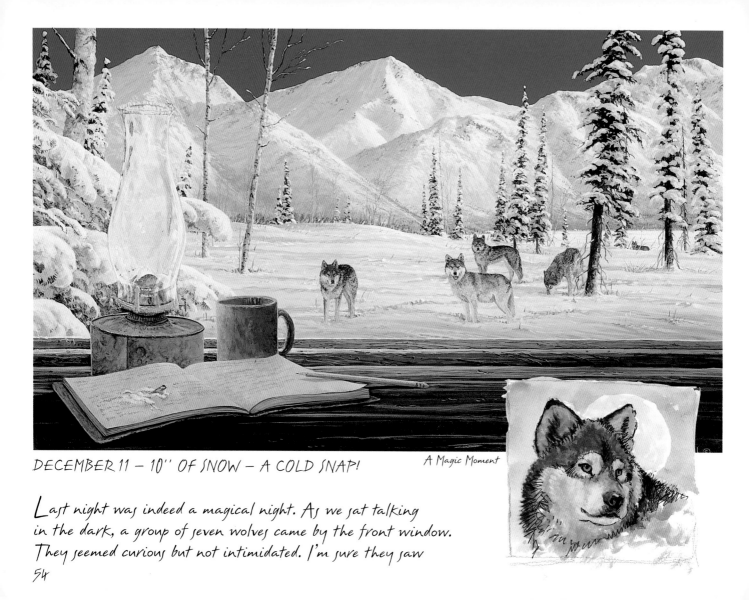

DECEMBER 11 – 10'' OF SNOW – A COLD SNAP!

A Magic Moment

L*ast night was indeed a magical night. As we sat talking in the dark, a group of seven wolves came by the front window. They seemed curious but not intimidated. I'm sure they saw*

54

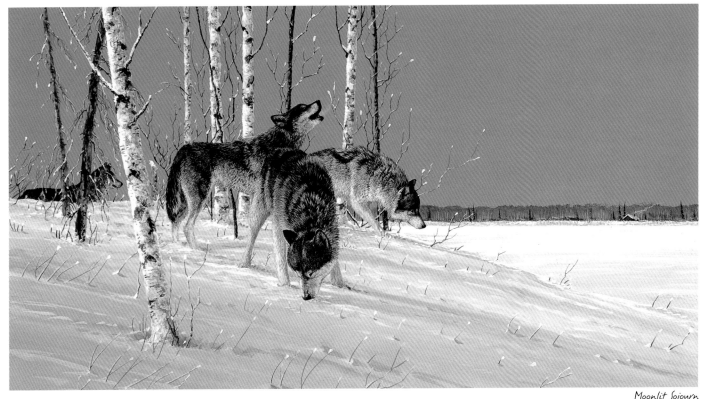

Moonlit Sojourn

us through the glass, captives in their world. A large female appeared to be their leader. We watched them for about ten minutes. I've never been so awed — this sense of fulfillment will undoubtedly stay with us throughout our lives.

Dec. 12 - Warmed up to thirty-six below. The birch trees were snapping in the cold this afternoon, as the moisture within them froze and expanded, splitting their trunks. I caught a glimpse of the same group of wolves across the lake.

Everything I did today turned
into a farce. The handle on the
axe broke (of course it's only
sixteen or eighteen years old).
Ran out of Payne's gray paint.
Decided to go into town for
another tube and found I hadn't
plugged in the car last night, so
it wouldn't start. Took two hours
for it to crank over. Hooked up
some dogs for a nice run . . .
you guessed it. Some got so badly
tangled up I had to unhook
about half of them. Then
they'd mill around and of course
that got the hooked-up ones
more excited. Finally I sat down
in the whole mess of 'em and we
had a great talk. What a day!

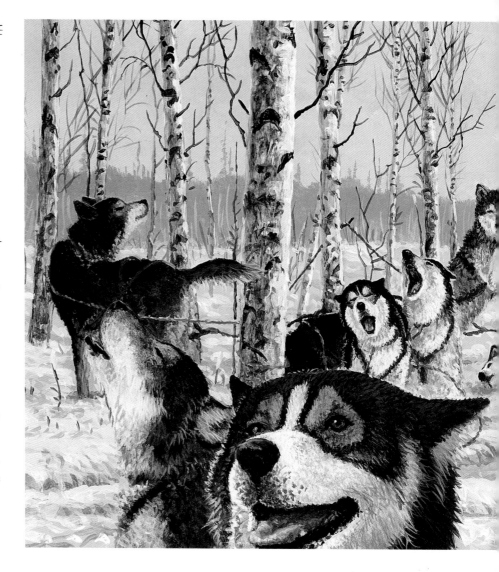

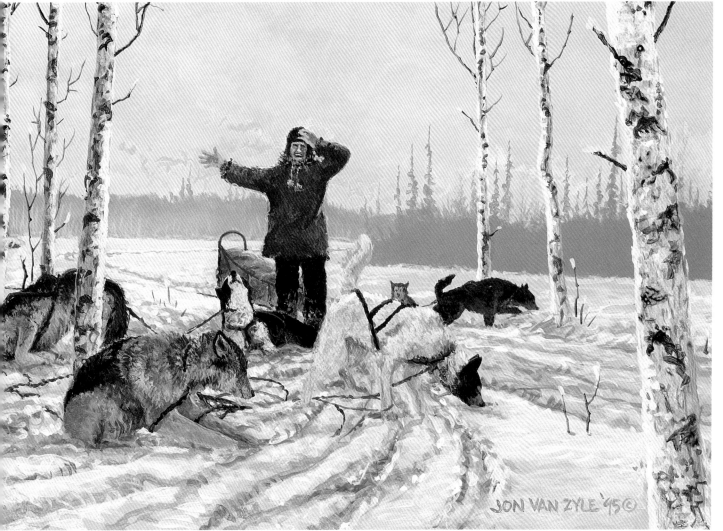

JON VAN ZYLE '95©

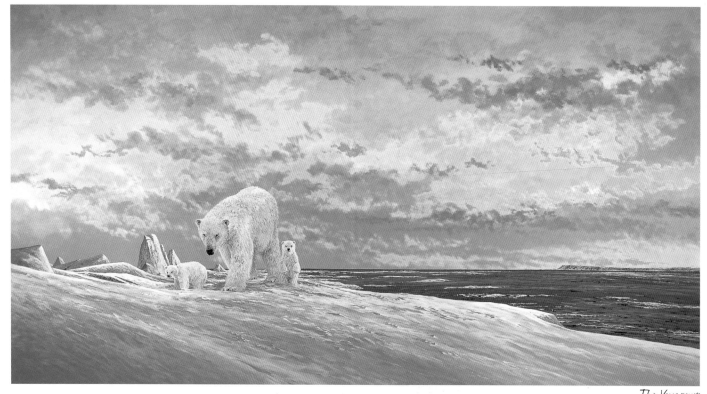

The Voyageurs

JANUARY 9 – SUNNY, BRIGHT – MORE SNOW 8" – 0 DEGREES

In the wilds, polar bears are elusive. I've seen only two in my years of travel in the Arctic, once on the 1979 Iditarod near Igavik, the other in Siberia on the Hope Race in 1991. I wanted this painting to convey the vastness of the Arctic, balanced with the terrific size of these ghost bears.

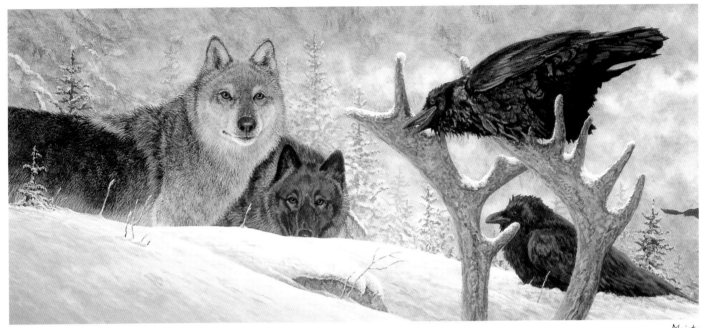

Moiety

JANUARY 16 — MINUS 12°, DRY — ALMOST 7 HOURS DAYLIGHT NOW

While snowshoeing, I came across a flock of ravens, all raucous and flighty. Took another few steps and all of a sudden I saw the wolves. A long-dead caribou was on the menu. The interaction between the wolves and the birds was respectful yet almost playful, as if they were partners of the wild. I thought about the Tlingit, Haida, and Tsimshian Indians of Southeast Alaska, who revere the two animals as powerful moieties, or two equal halves.

very abstract — nice design

59

FEBRUARY 15
MINUS 15°, 9+ HOURS DAYLIGHT

The wind on the river blew in our faces all night. At times the dogs quartered into the wind in their harnesses. The lights in the sky were day bright, sometimes dipping so low I could almost touch them. The dogs heard them before I did. They'd prick up their ears and look around, and then a second or so later I would hear the northern lights whistle and pop. I could smell the wood smoke from Miska's cozy cabin before I saw his lights.

birch forest
w/ some spruce

river thru trees

shorter than most
add m in rear

16 dogs

foreground shadow on top.

homey feel. w/ closeness
of foreground trees "like spying upon."
maybe add figure in - going about chores...
(viewer is unseen)

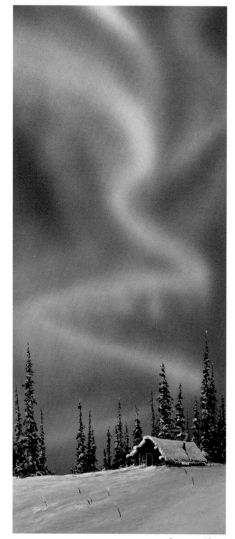

Coming Home

60

FEBRUARY 23
CLOUDY, WARMER, 20°
9½ HOURS DAYLIGHT

Our two Bengal guard cats, Leo and Asia, enjoy sitting in the window watching the bird feeders for invading chickadees. They warn us of the birds' approach with twitching tails and restrained verbal chirps.

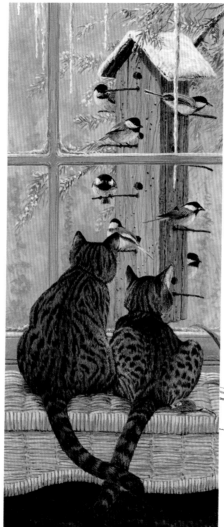

Of Seeds and Dreams

The chickadees and redpolls are aware of the cats and defy them at times, knowing full well the feline hunters are behind glass. Comical situations like this remind us that not all wildlife-viewing in Alaska is outdoors.

—ASIA—young kitten
white rims around
eyes & cheeks & mouth
must have for breed
orangy beige—
—dark spots

61

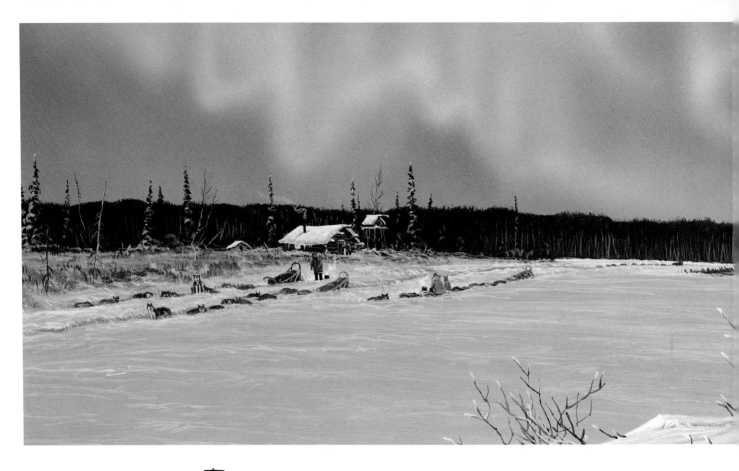

MARCH 8
9" NEW SNOW – 5°
11½ HOURS DAYLIGHT

The cabin was warm and cozy. I wanted to stay, to help myself to a second cup of coffee, but then another dog team came into the checkpoint. My dogs had wolfed down their food three hours ago and were nervously waiting to get back on the trail, running the Iditarod. As I stepped out into the cold

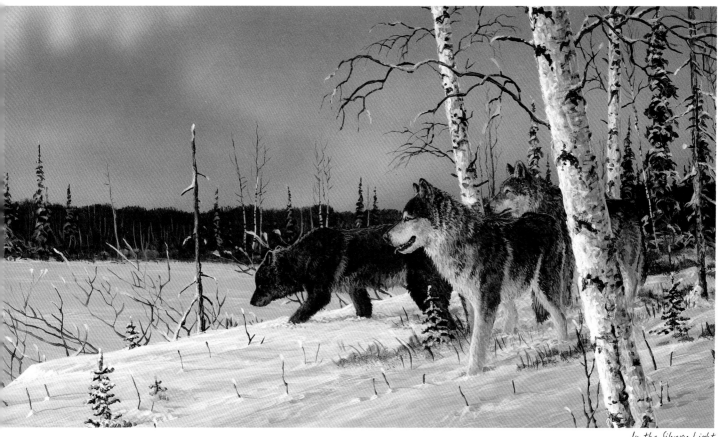

In the Silvery Light

night, I caught a glimpse of movement on the far riverbank . . . there . . . in the silvery light. . . .

 March 28 - Home from the Iditarod. It's crisp and cold tonight, but I know spring's just around the corner. Soon another year in Alaska will begin.

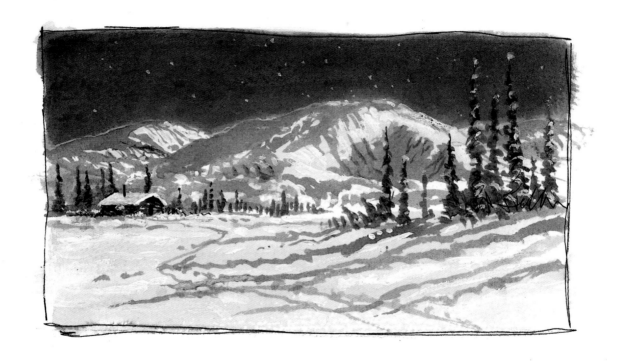

64